UNICORNS
COLORING BOOK

MARTY NOBLE

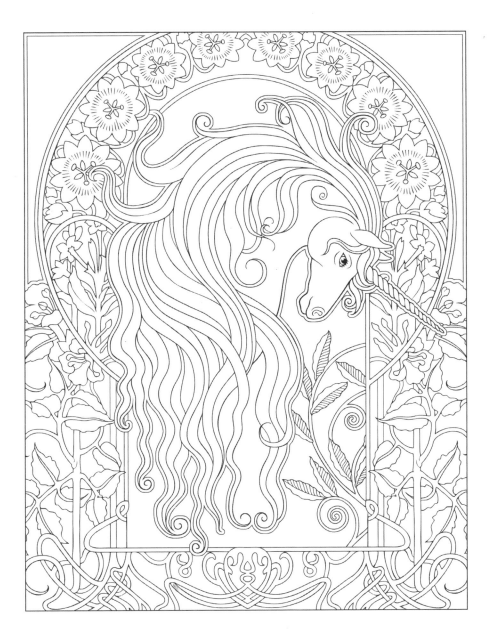

DOVER PUBLICATIONS, INC.
MINEOLA, NEW YORK

The charming designs in this delightful coloring book will appeal to aspiring artists and experienced colorists alike. More than thirty wonderfully detailed drawings feature the legendary unicorn in a variety of backgrounds—among them fairy-tale settings, flower-filled gardens, a lily pad-filled pond, and beautifully symmetrical mandala-like designs. The perfect canvas for experimenting with various media and techniques, the coloring pages are unbacked and perforated so that you can easily display your finished artwork.

Bibliographical Note

Unicorns Coloring Book is a new work,
first published by Dover Publications, Inc., in 2017.

International Standard Book Number

ISBN-13: 978-0-486-81493-3
ISBN-10: 0-486-81493-9

Manufactured in the United States by LSC Communications
81493906 2019
www.doverpublications.com

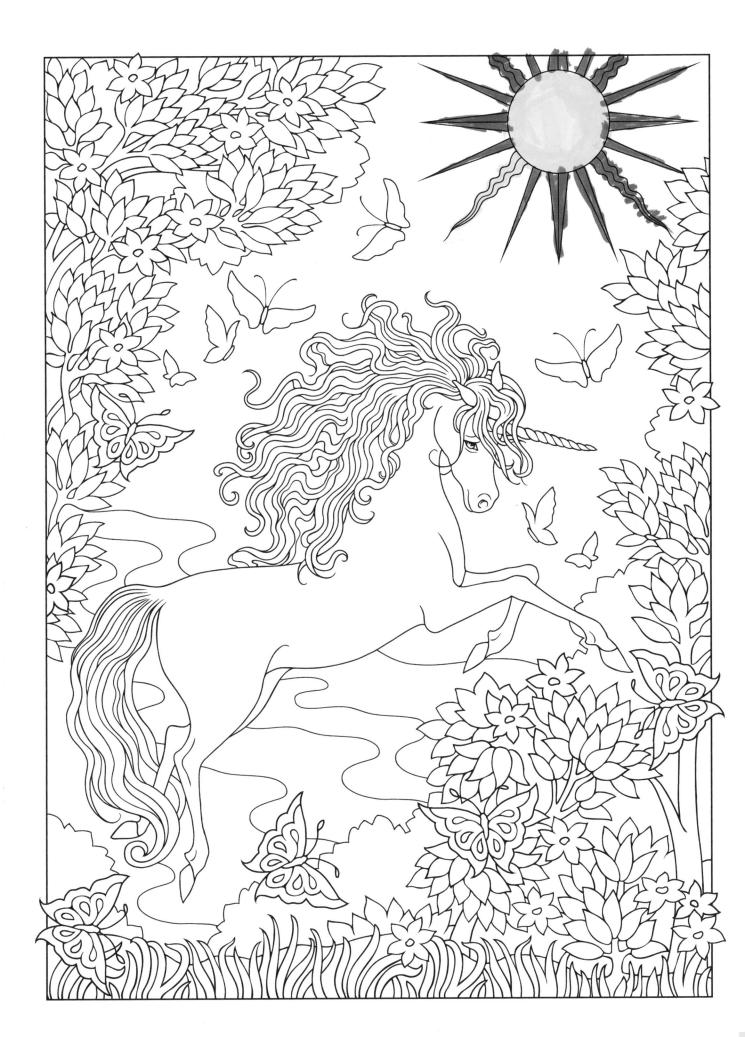

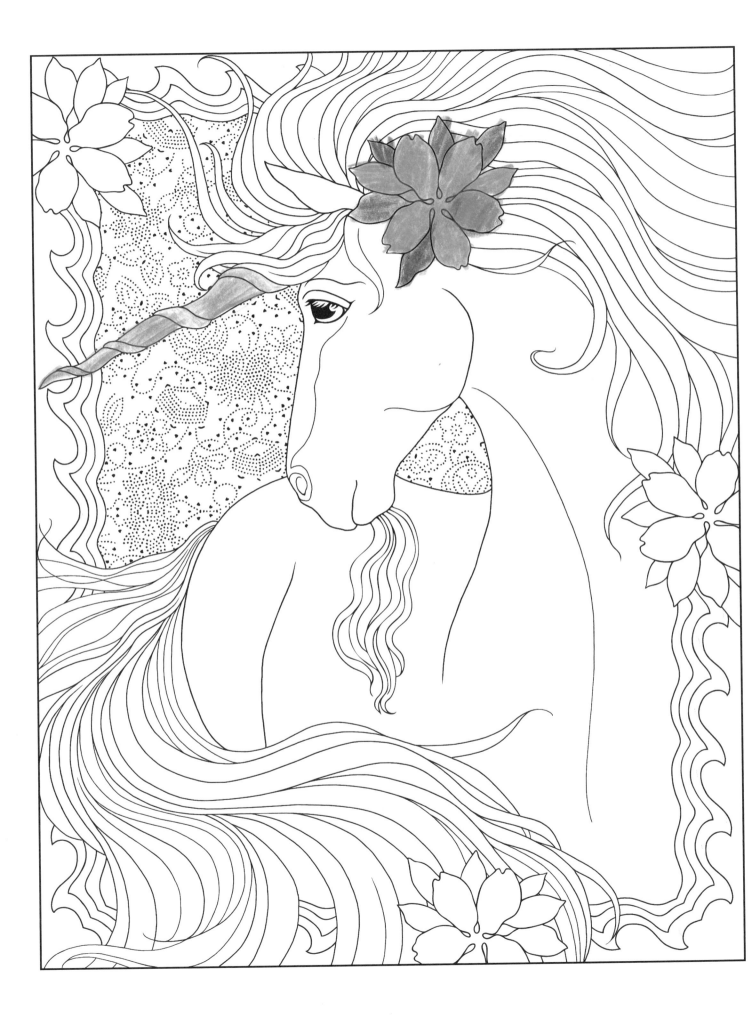

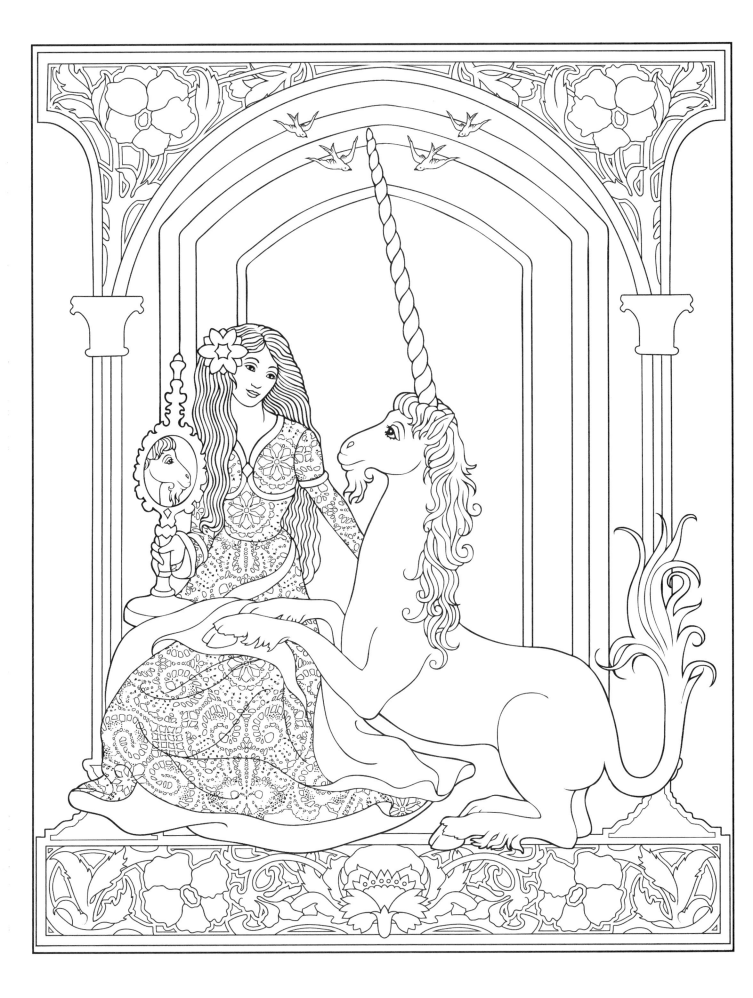

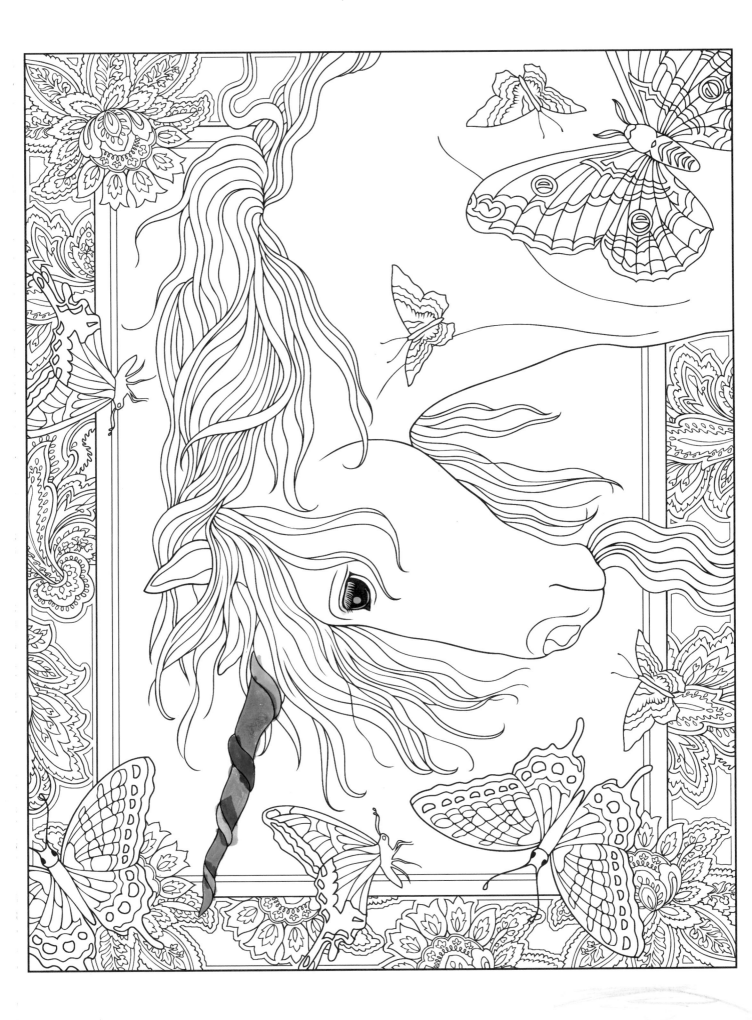

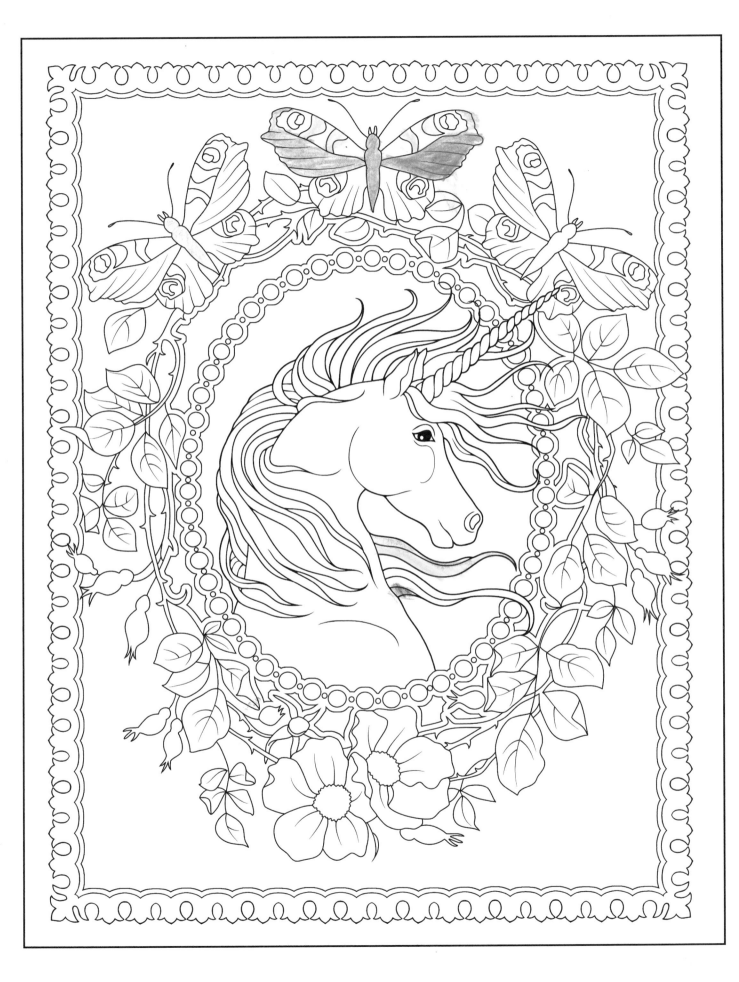

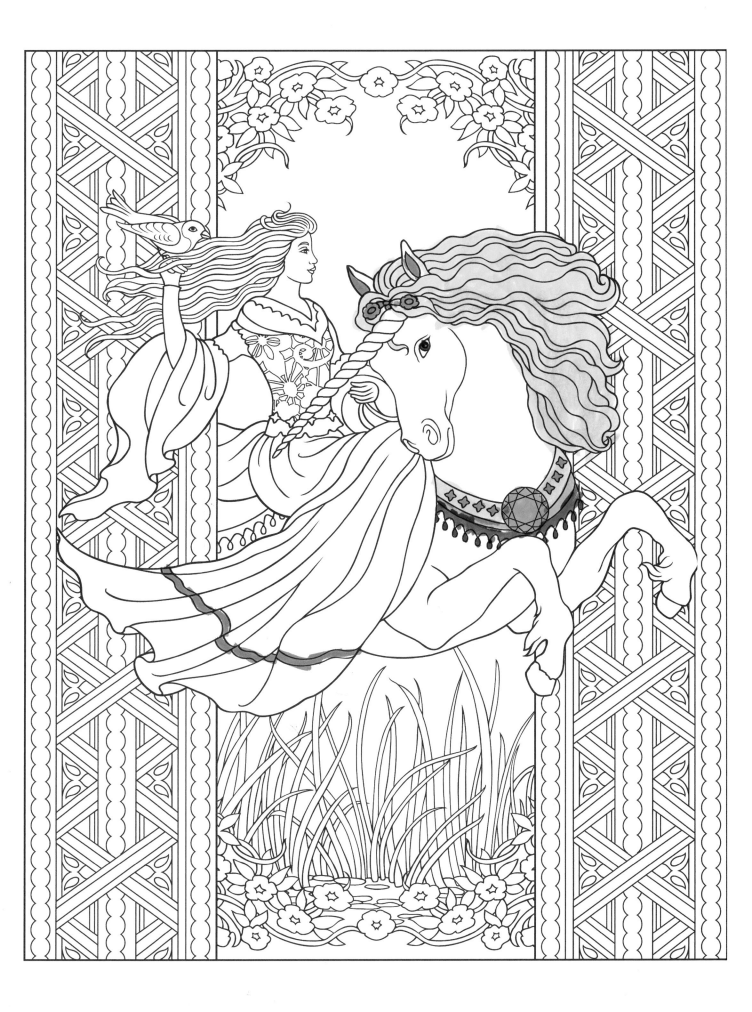

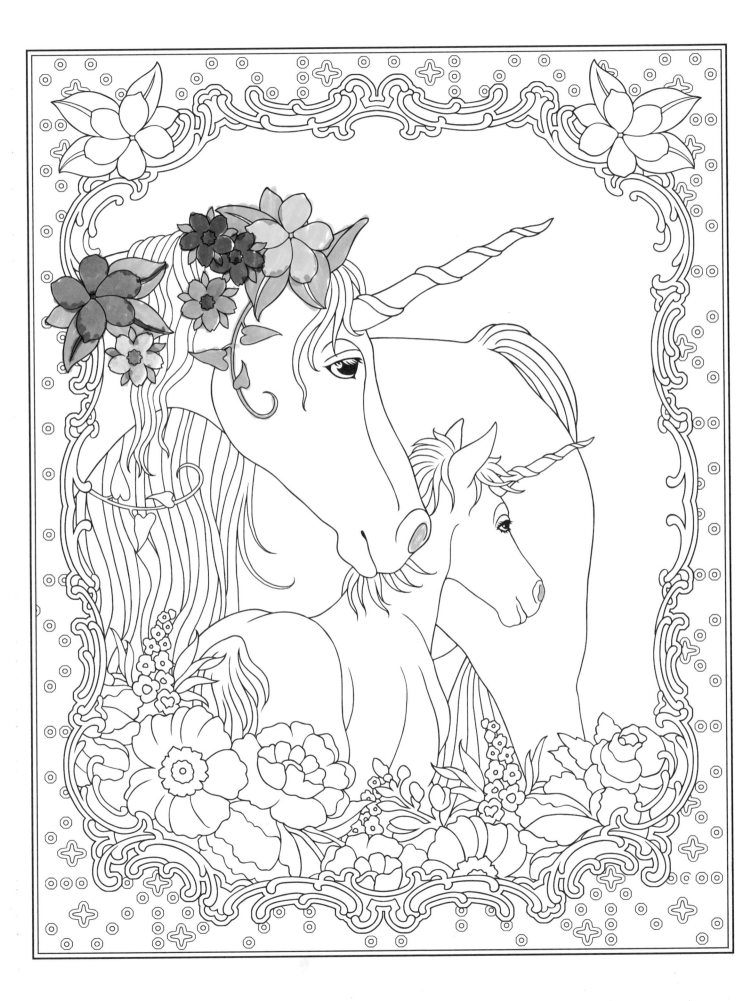

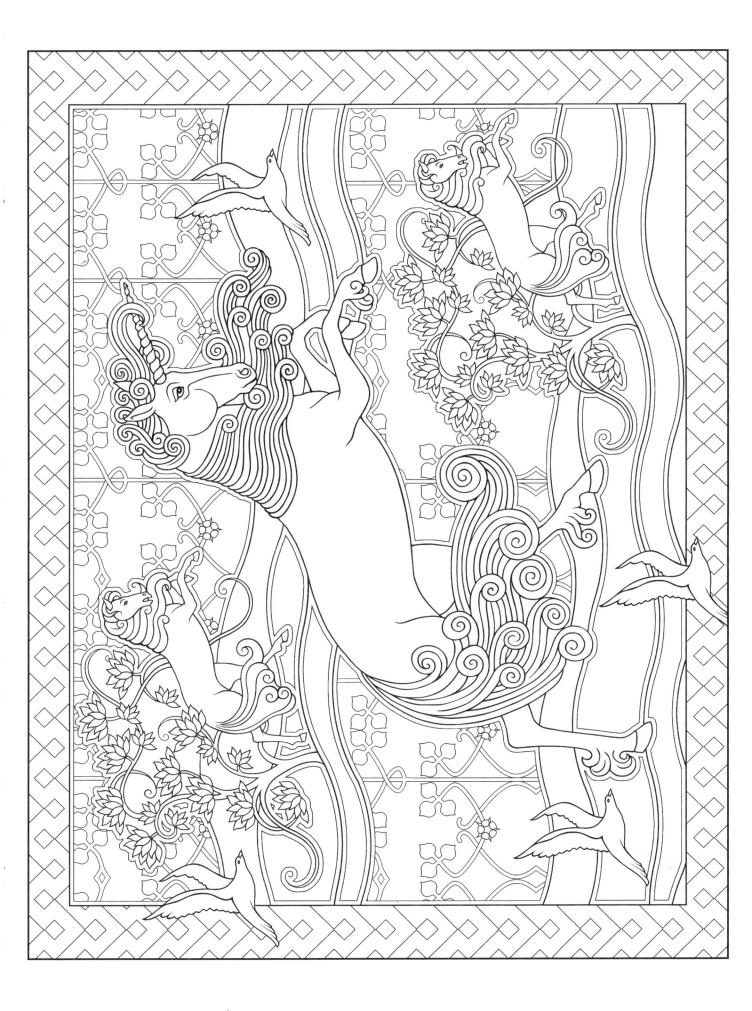

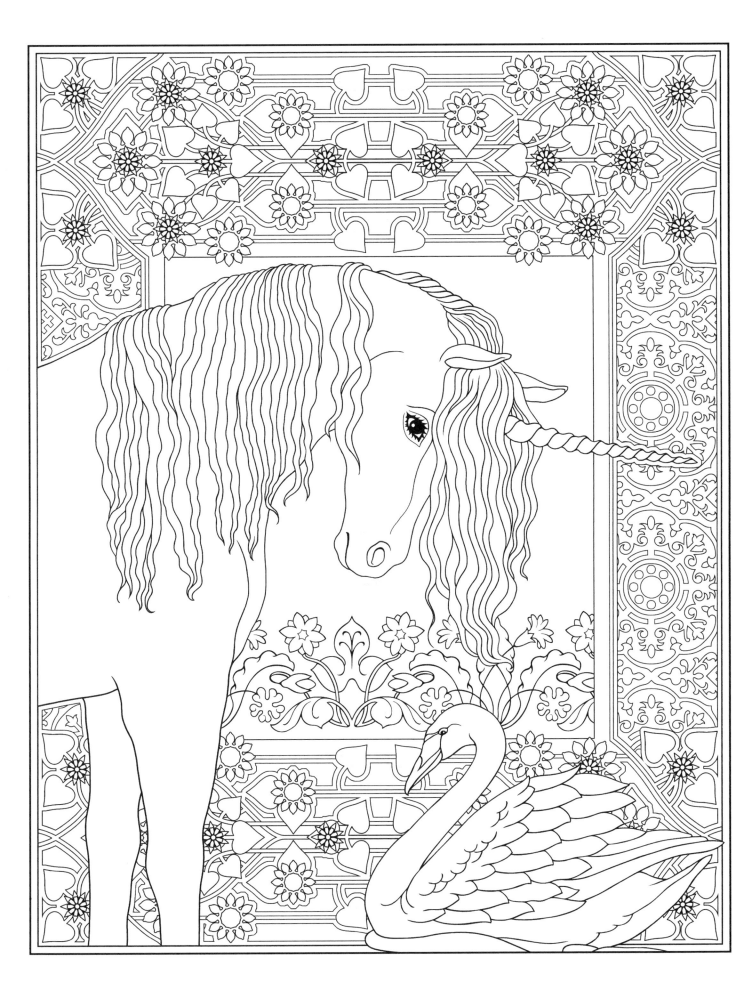

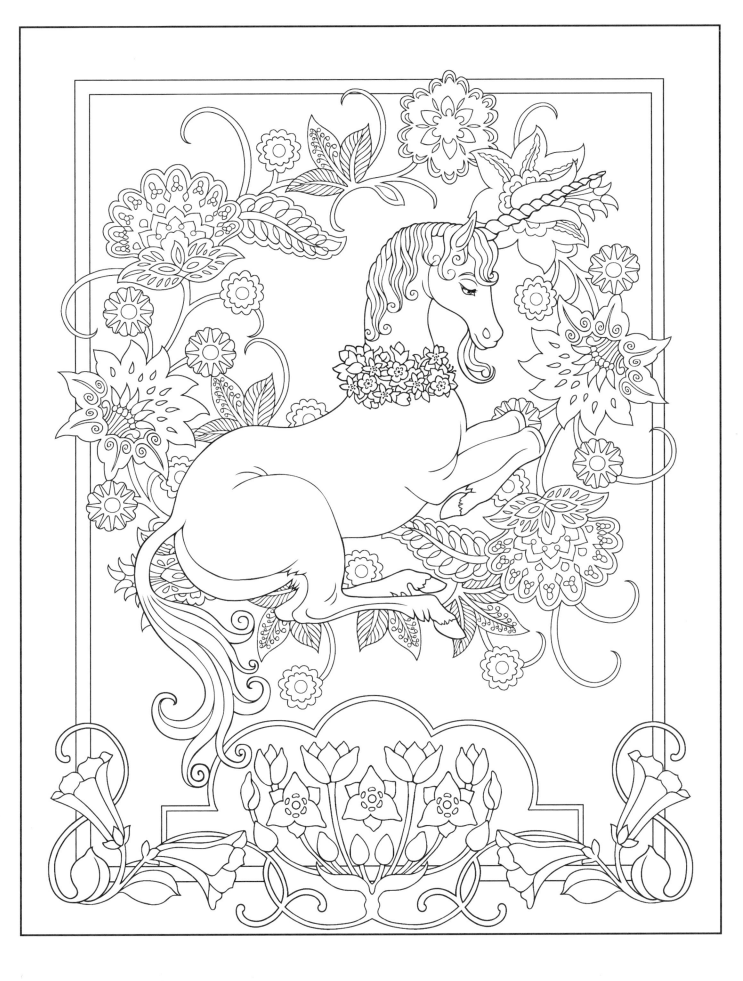

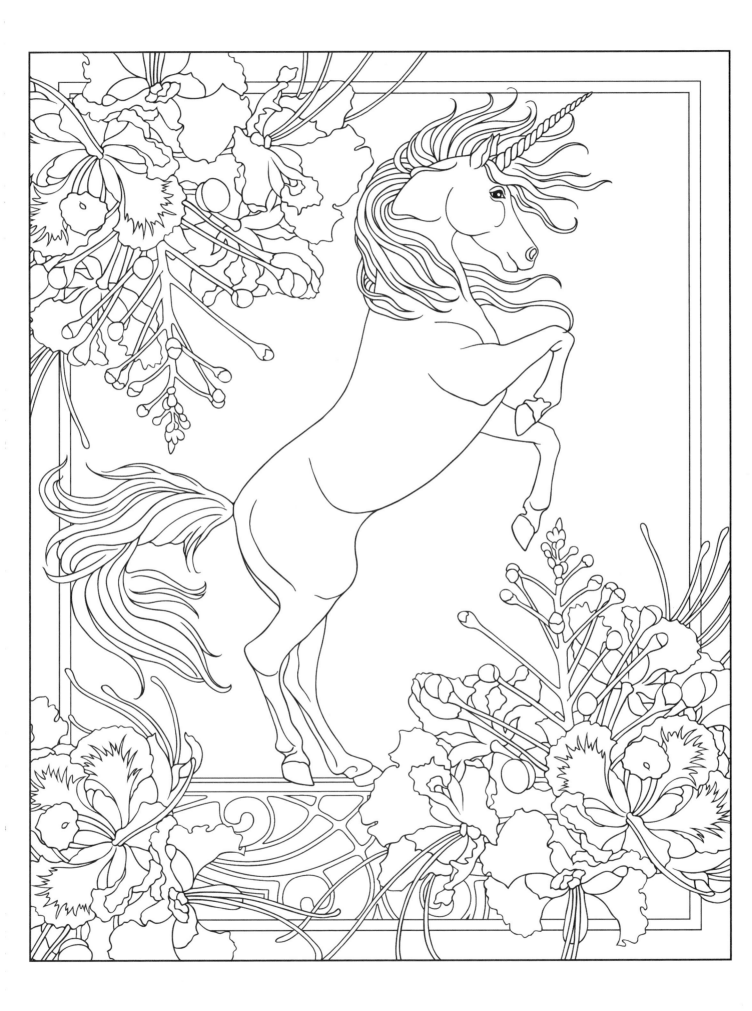

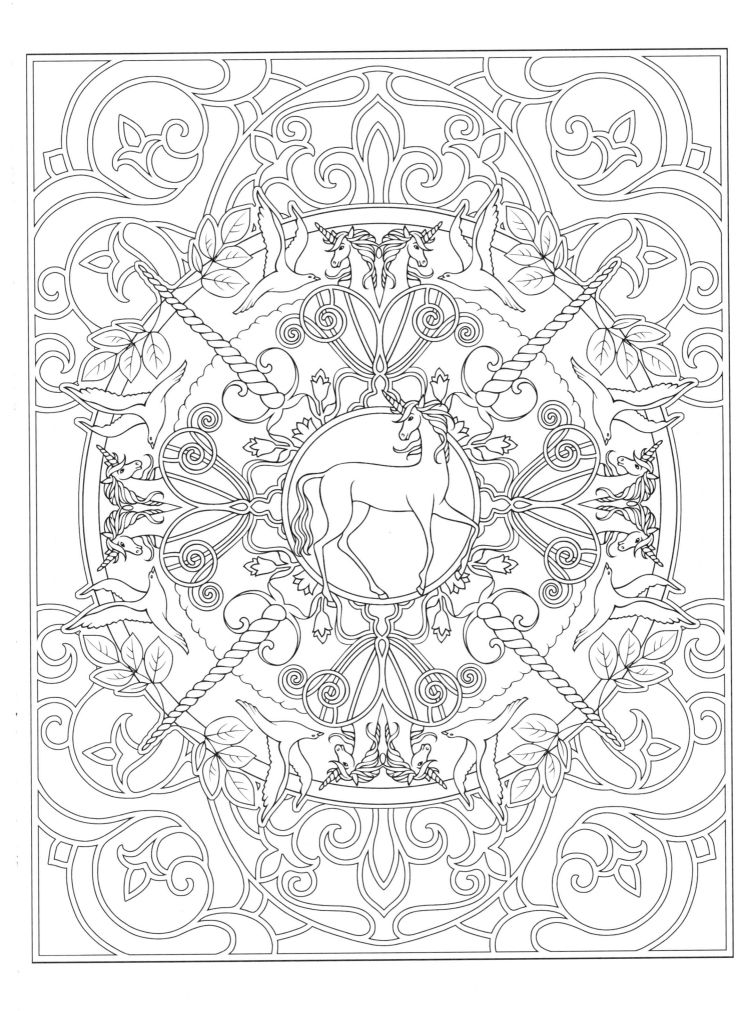

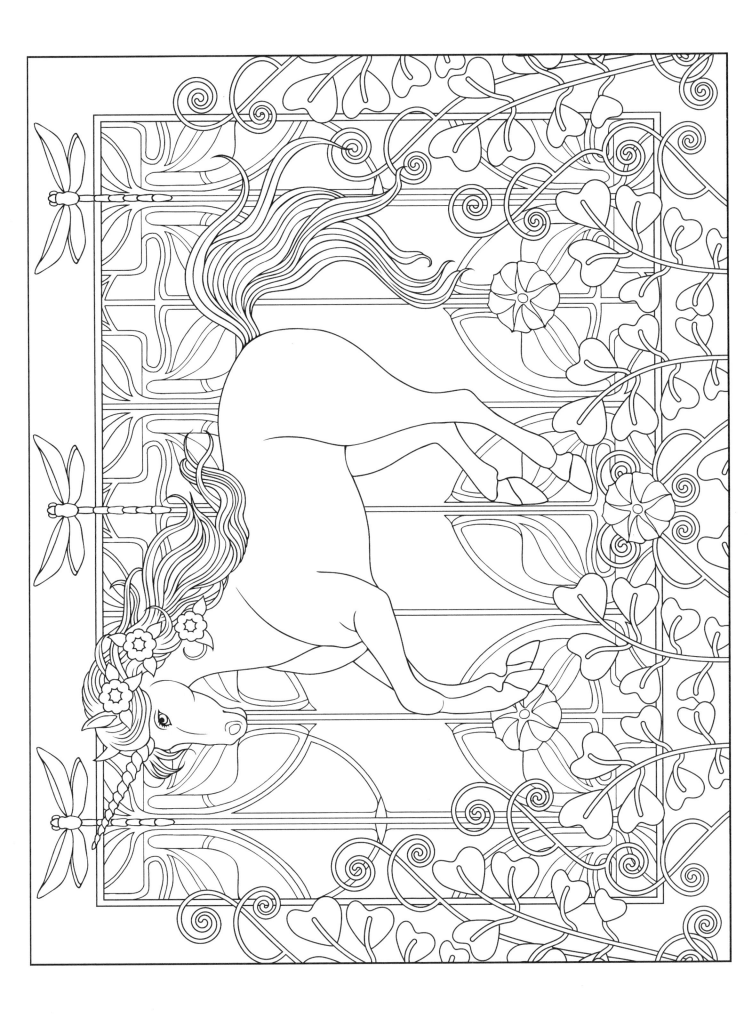

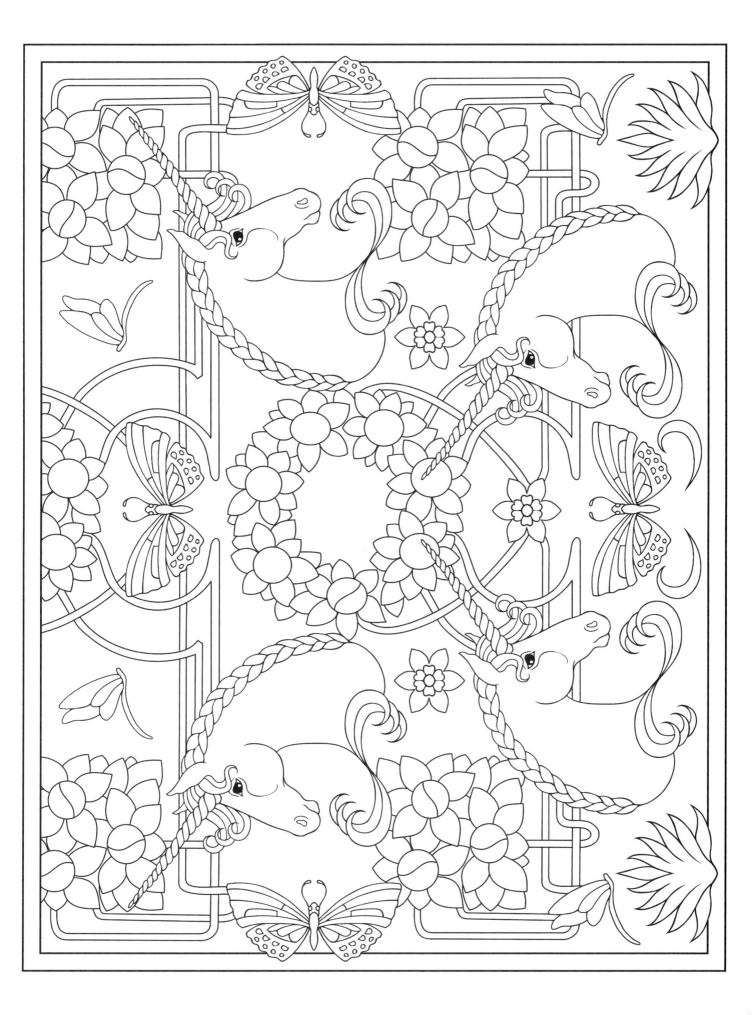

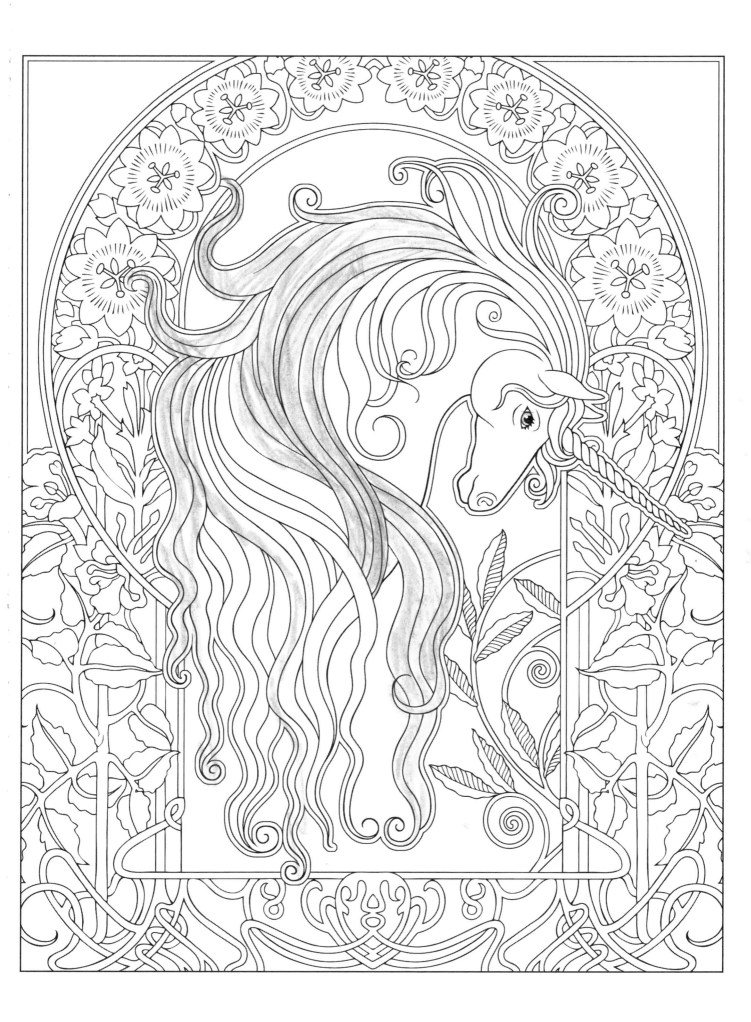

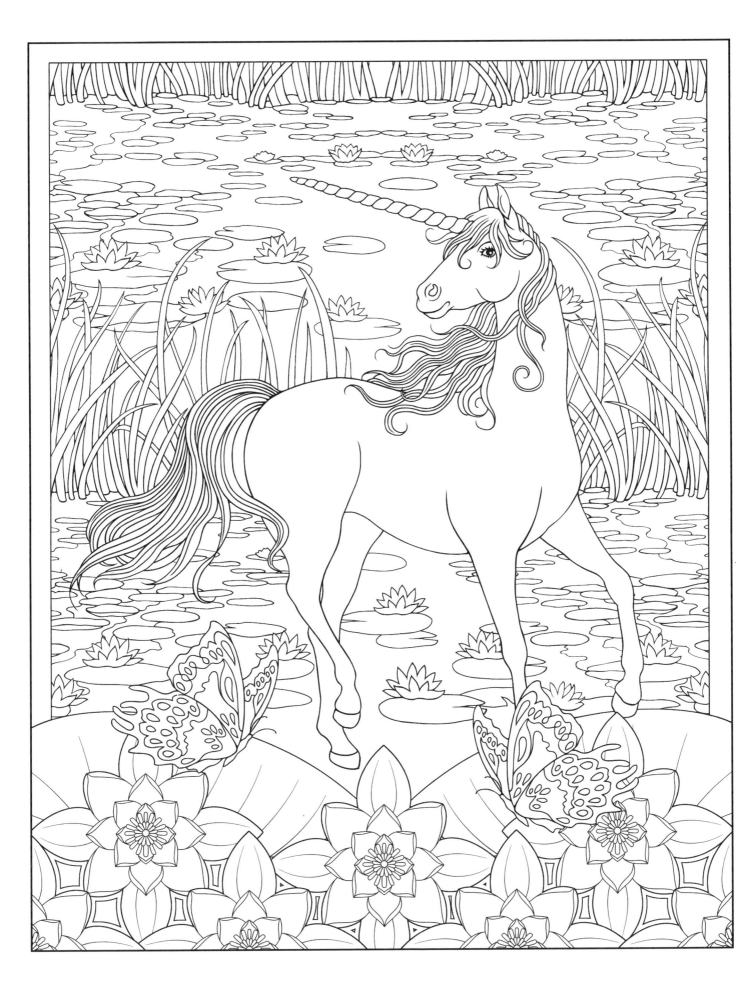

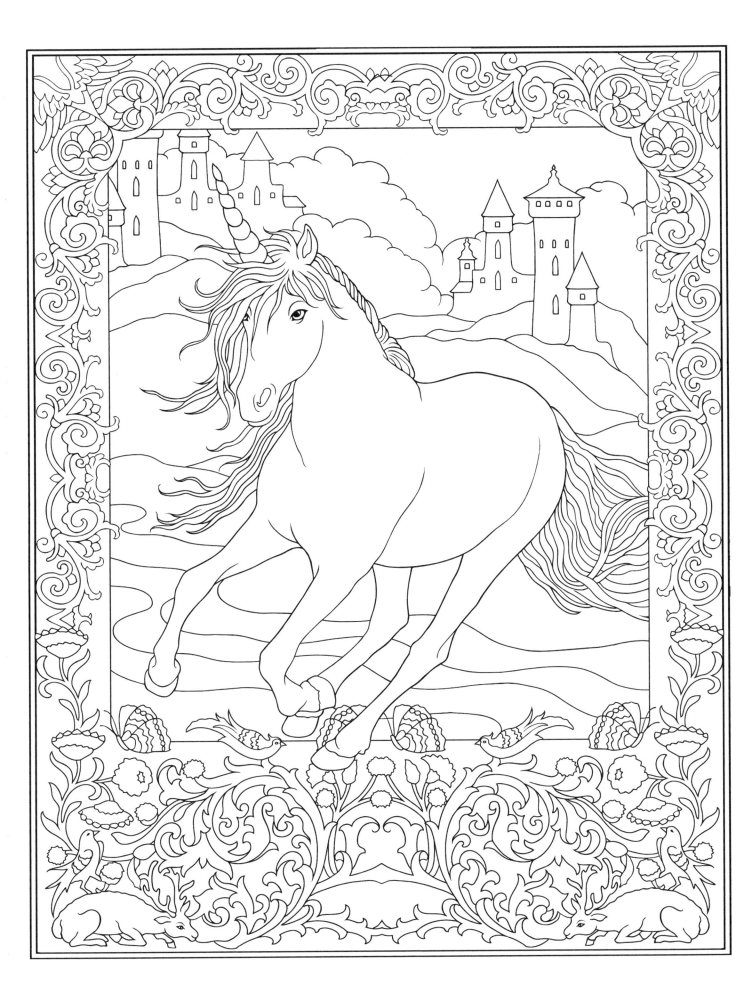

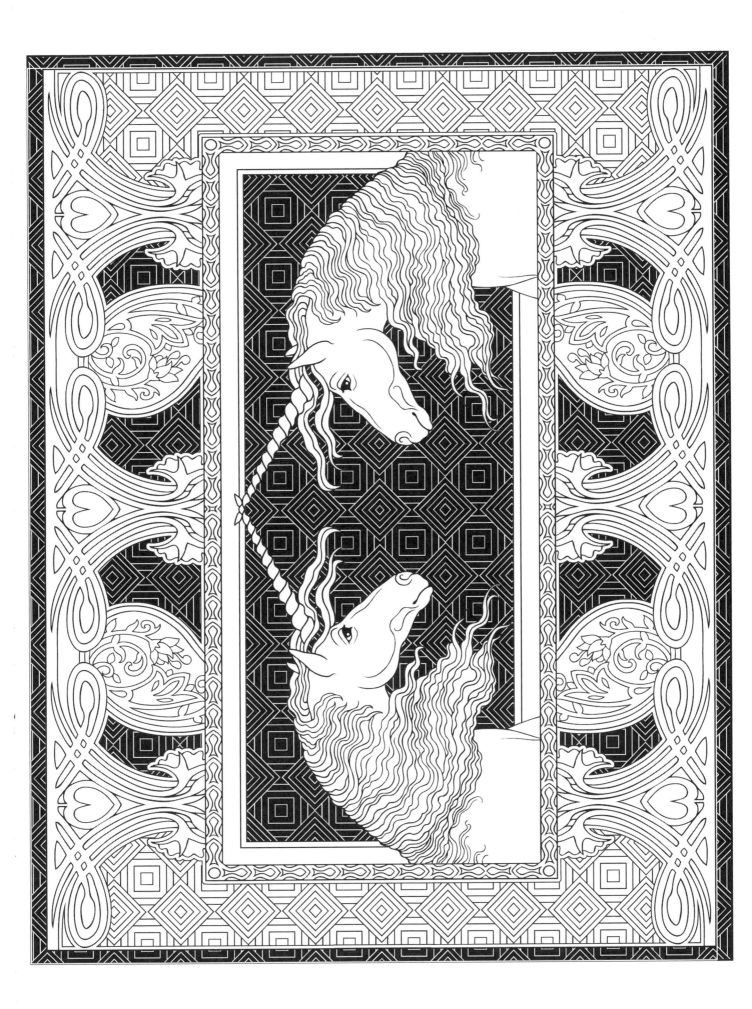

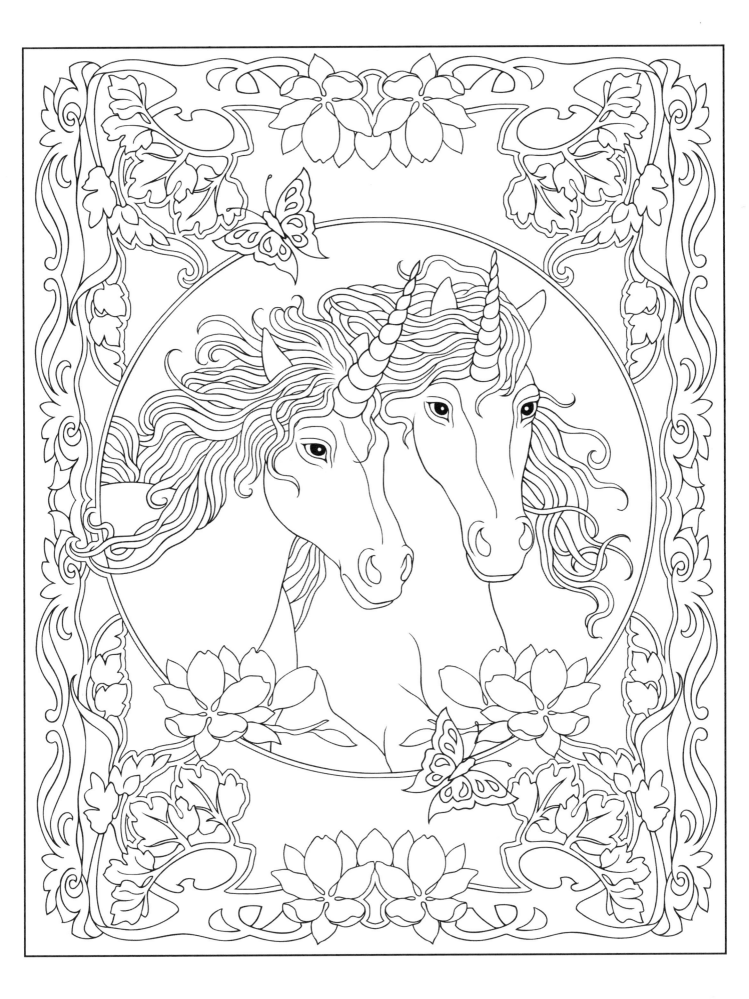

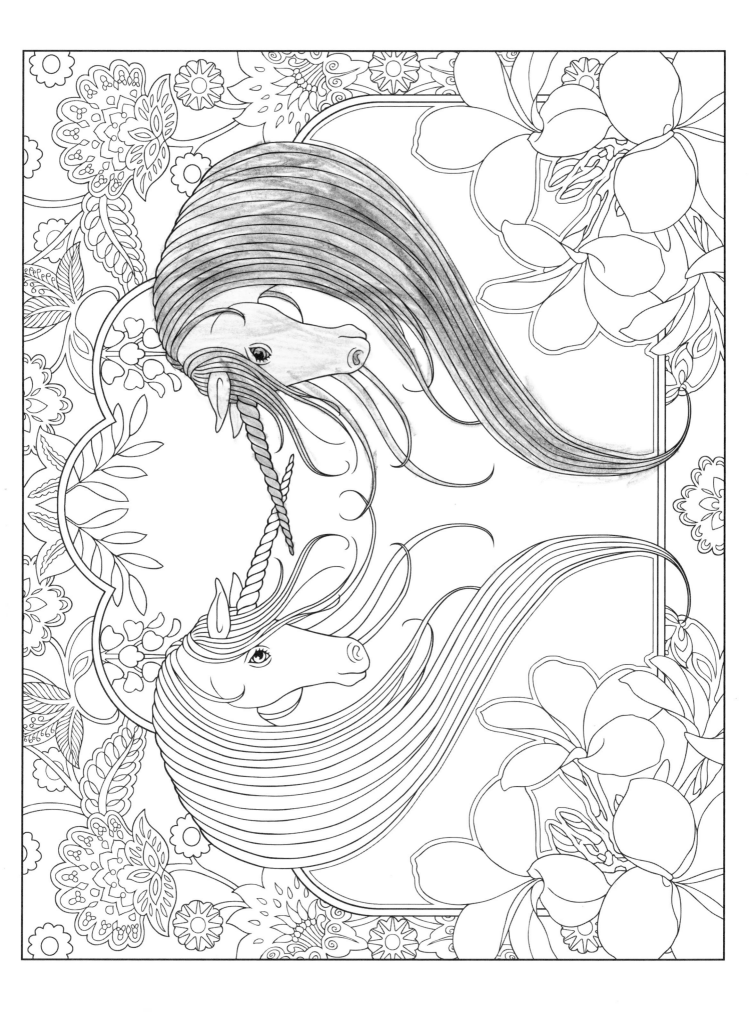

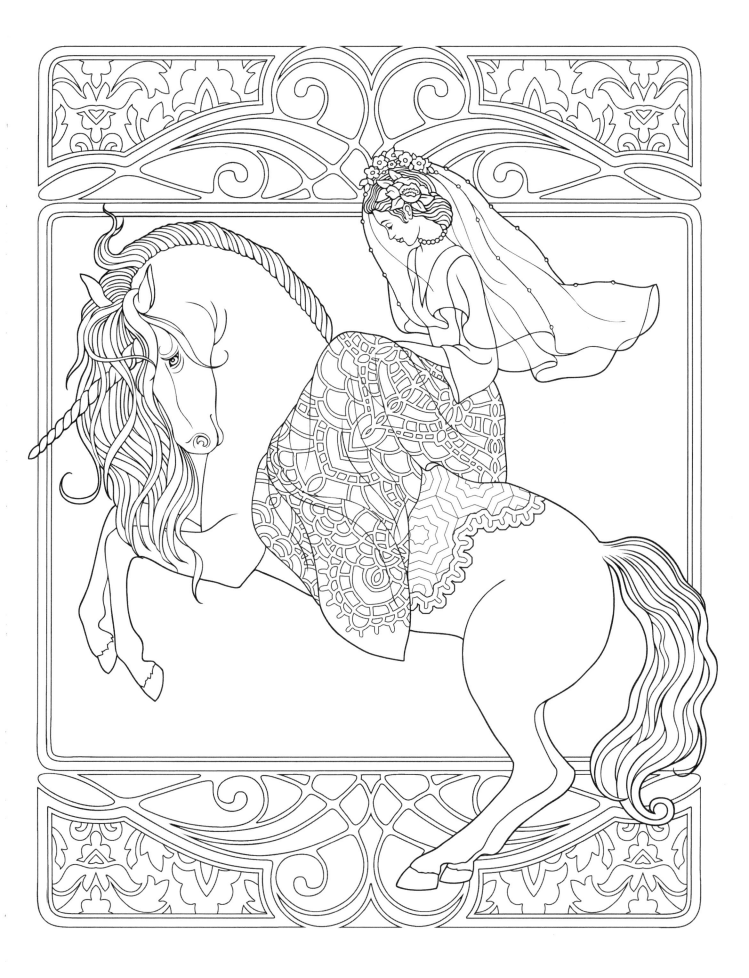

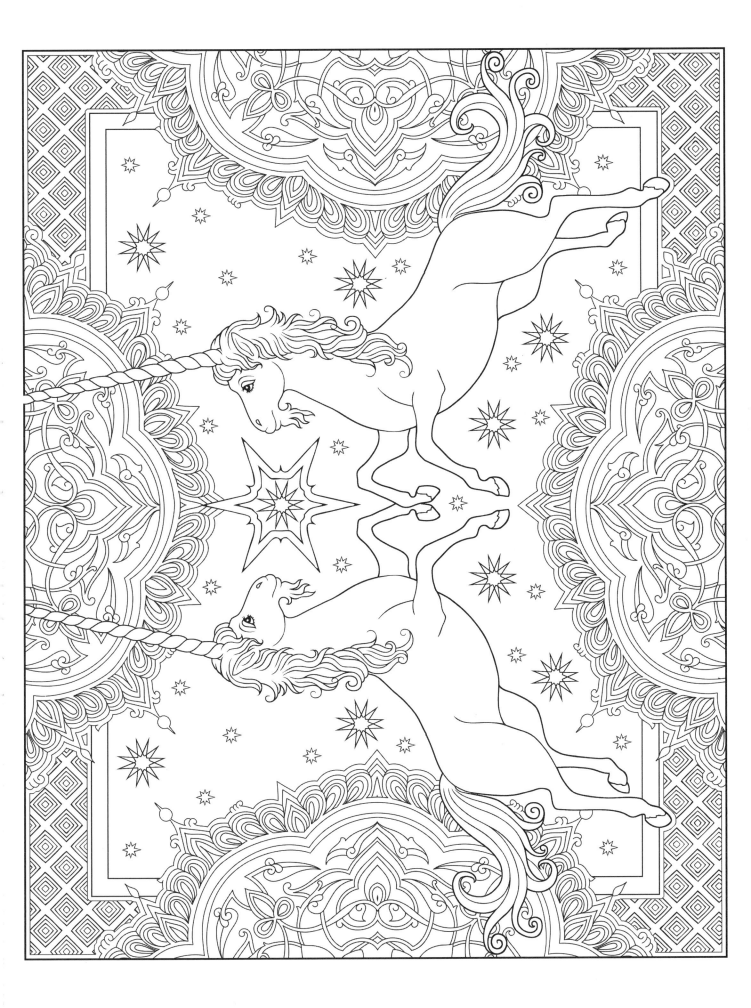

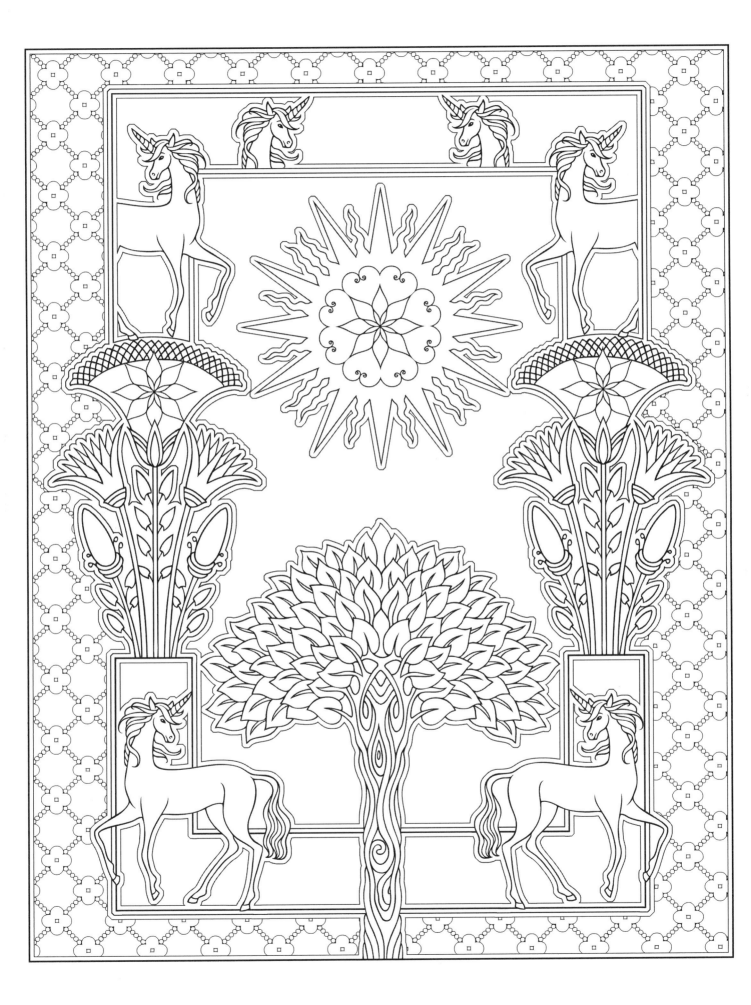

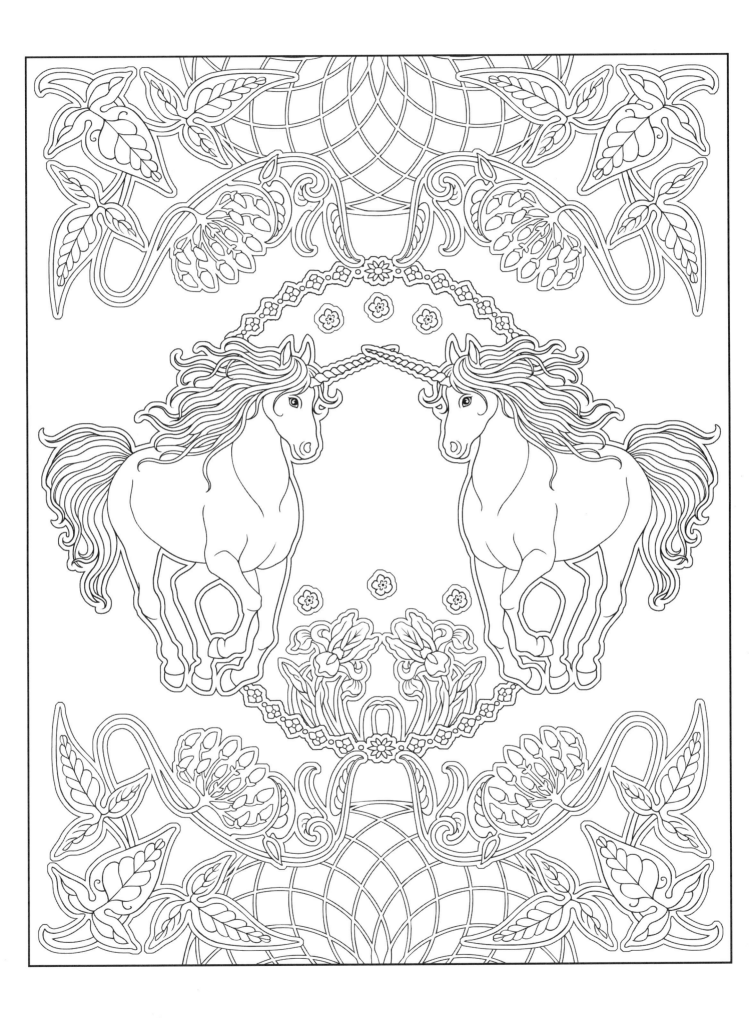

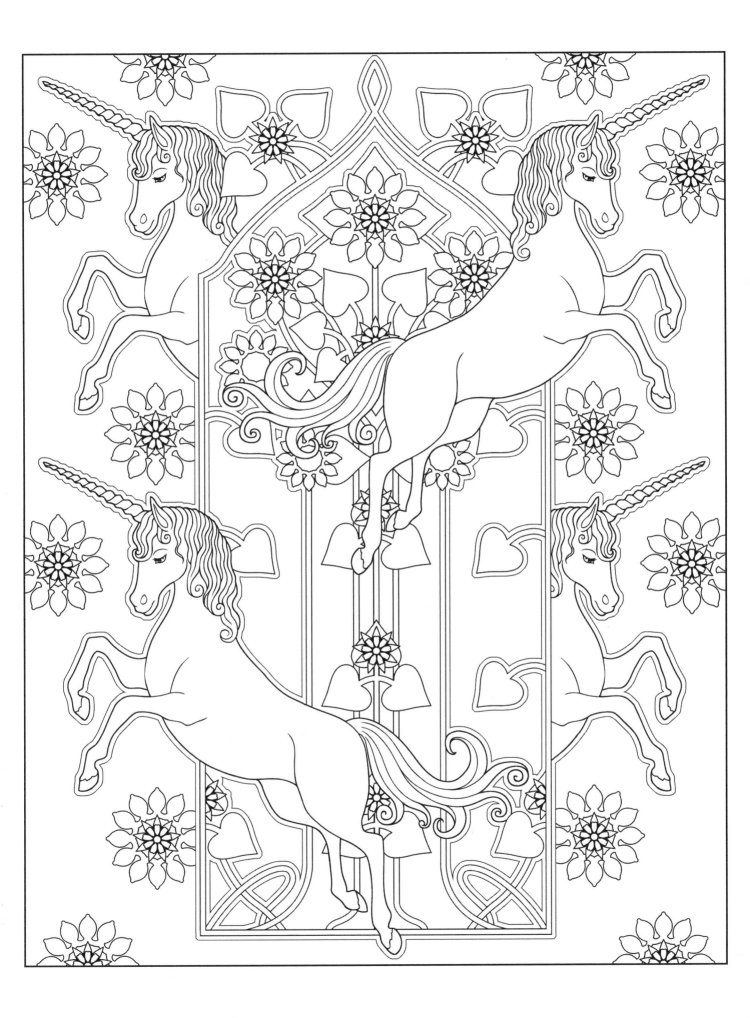

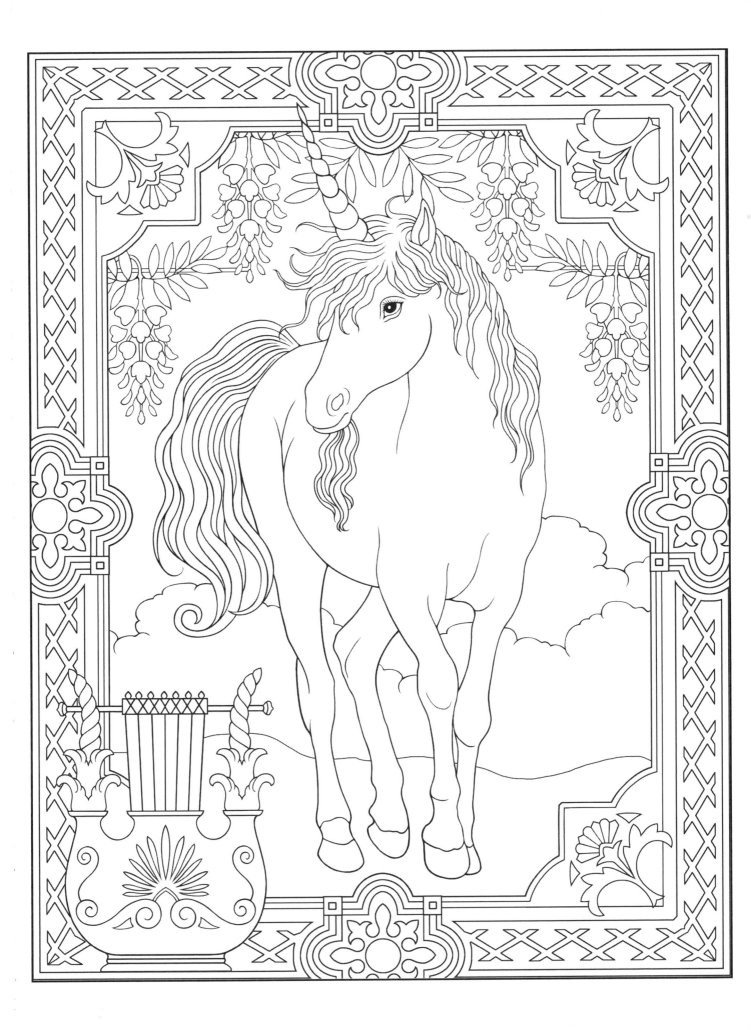

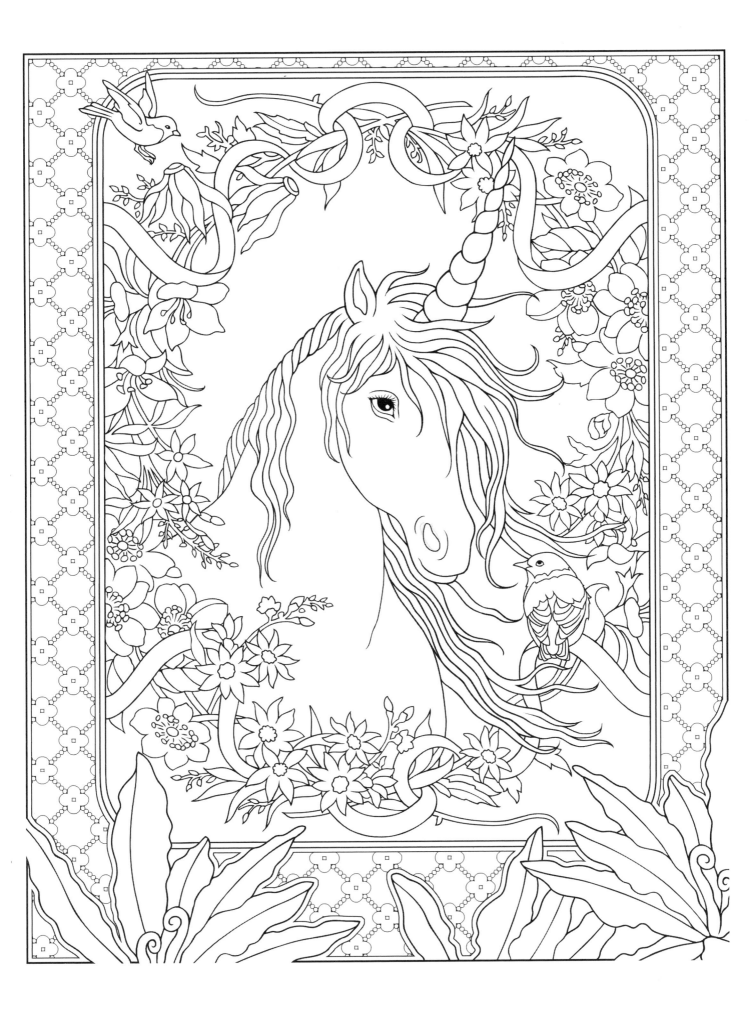

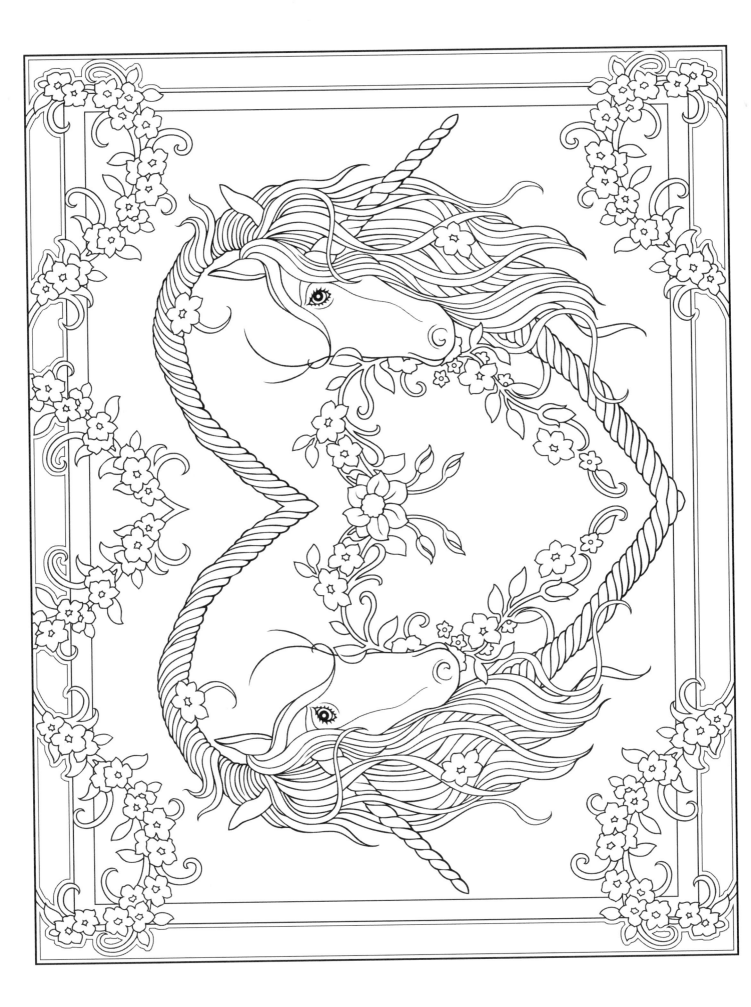

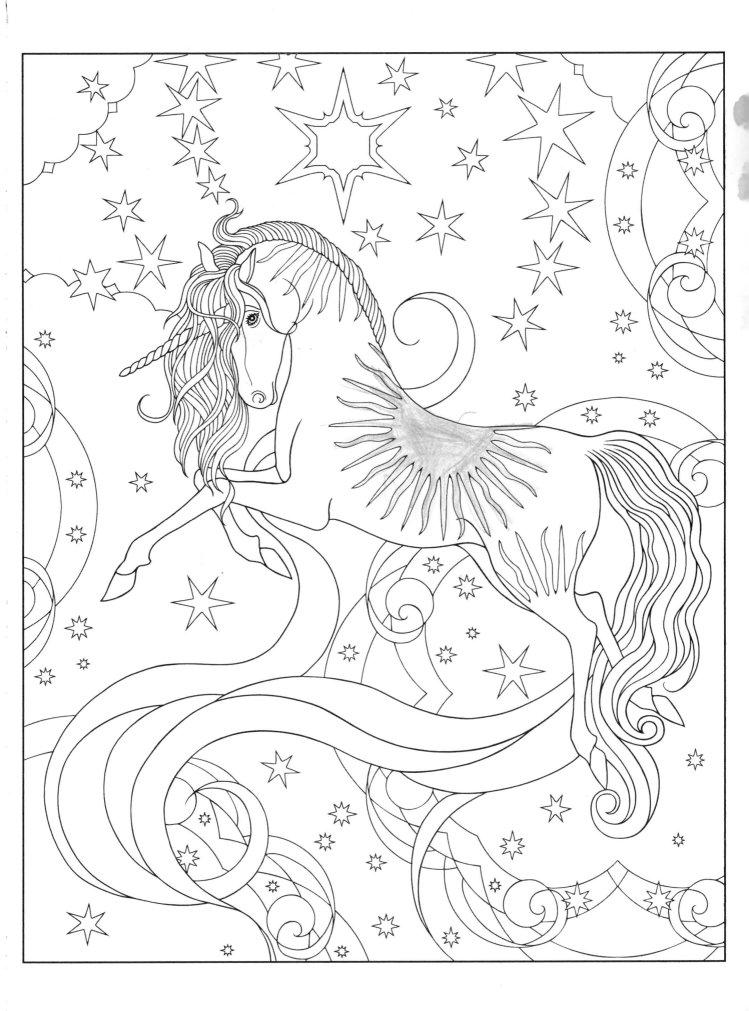